*The Pocketknife Bible*
a collection of poetry and art

ᘓ

by Anis Mojgani

Write Bloody Publishing
*America's Independent Press*

Austin, TX

**WRITEBLOODY.COM**

Mojgani, Anis.
1$^{st}$ edition.
ISBN: 978-1938912528

Cover Art by Anis Mojgani
Author Photo by Teri Mojgani
Edited by Dalton Day, Wes Mongo Jolley, and Hanif Willis-Abdurraqib
Interior Layout by Andie Flores
Cover Layout by Andie Flores
Type set in Bergamo from www.theleagueofmoveabletype.com

Printed in Tennessee, USA

Write Bloody Publishing
Austin, TX
Support Independent Presses
writebloody.com

To contact the author, send an email to writebloody@gmail.com

MADE IN THE USA

# THE POCKETKNIFE BIBLE

*to 8316 Willow street*
*2 blocks from the library*
*7 to the river*

*I had a pocketknife once.*
*Back when I was not much older than you are.*
*I cut my thumb the first time I closed it. The second time I closed it I cut the other.*
*It slept on the windowsill beside my pillow. It was precious. Like a secret*
*that sat in plain sight. Every fall the leaves would turn brown*
*and the wind would sweep them south to the gulf. Every spring they would return*
*with the geese and with the grasshoppers in their mouths.*
*In winter I drew on the frost of the glass.*
*In summer I ate popsicles on the front steps. Every night I would pray.*
*Not for things or people but for whatever power that turned*
*the machinery of earth and stars, to make of my heart a lamp,*
*glowing with light. I raced a crawfish. I had a birthday cake*
*with dinosaurs on it. My mother marked my growth in pencil*
*on the doorframe. My eyes were dark and wet marbles.*
*And they traveled with me, back and forth,*
*between this world and others.*

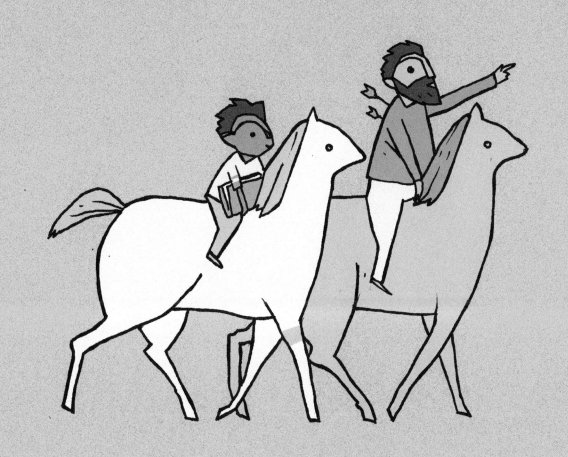

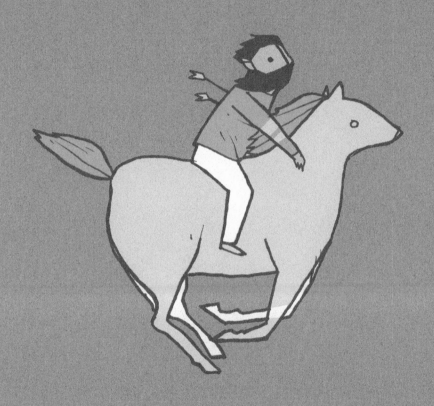

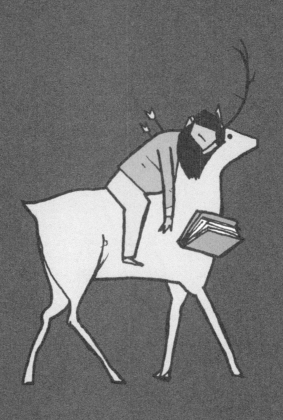

The book is aching for the tree
...return to me.

—Califone

I.

Magnolias cover the ground. The sidewalk in front of the Freret Mansion is made of bricks and the bricks are all out of order and covered in moss. The mansion is the biggest house in New Orleans. It's spooky. Its yard is like a jungle and there're so many magnolia trees on its sidewalk, that even in the daytime it is dark. We hold our breath when we walk past in case there are any ghosts around but it's hard because the magnolias smell so sweet and the whole block smells like them and it is my favorite smell. Their petals are soft and white like butter left out. They feel like my baby brother's cheeks.

•

In January the porch freezes. Me and Shoke use our shoes to skate across the ice before school. On cold mornings Mom makes oatmeal. On cold cold mornings she lays my pants over the heater while I stay under the covers. I can see my breath move out of my mouth. It's like having a superpower. I feel like Iceman or the North Wind. I breathe on the window and turn it a different color. I move my finger across the glass and draw a giraffe. You can only see it when there's something dark on the other side. This is also like a superpower.

When it gets really cold Pop goes under the house to wrap the pipes and turn off the water. Mom ties blankets around the plants in the garden and the ones in pots they pull inside. On Saturdays when it's warm we have to help with the yardwork. The shovel gives my hand blisters.

•

Me and Mom and Shoke plant a tree in front of our house. We have a new brother. His name is Naysan. He's like a sailboat. A chubby sailboat. His name means spring raincloud. Shokufeh means blossom. I don't know what Parviz means. He's just Pop. I don't know what Teri means. She's just Mom. Or Carolyn if she's talking to Aunt Diane or Aunt Lynette. I don't like my name. It is only four letters but still sounds all corners and clumsy in my mouth. Like trying to chew the pieces of a plate. And no one says it right. It means companion. I wish my name was Mike.
It is only four letters and sounds like a knife.

1

•

Our house is between the streetcar barn and the train tracks.
It is white. The screen door is green. So is the porch. The paint is peeling on both.
It is three steps to the sidewalk or one jump. The kitchen windows are filled with plants.
Potatoes hang from the ceiling in front of the pantry's curtain. When the sun is big, Mom hangs
clothes on the clothesline in the backyard. She grows flowers in the garden up front. There is a
banana tree at the start of the driveway. With leaves bigger than my body. Behind the banana leaves is
the backyard. It is a country and a kingdom. A castle sits at the back of the backyard. It is a shed filled
with thrones made of car parts and Dr Pepper bottles. One side of the shed in the backyard we can go
in. One side we cannot. Pop says the roof isn't safe and might fall on us. I peek through the cracks in
the wood and the sunlight touching the dead grass is so still, I can see the dust floating in it. It looks
like if it touched me, it would make me magic. One time I went to climb a tree in the yard and the
branch had a caterpillar on it. It hurt. In the morning the backyard feels like a field, like a big and
open mouth. I run through the mouth and the mouth is singing.

•

The telephone poles on our street are covered with band posters. They're stapled into the poles and
are sometimes three inches thick and the bands always have weird names and I wonder what they
look like. I wonder if they sound like Joan Jett. I would like that. Joan Jett sings about jukeboxes and
rock n roll and makes my body want to yell in a good way. Shoke has a record with Joan Jett's face
on it. Joan Jett has the darkest eyes and I think she's beautiful but I don't tell anybody that. She looks
like kind of scary but I'm not scared of her. Sometimes Shoke holds my hand and I feel the opposite
of scared.

•

We eat the blossoms off the honeysuckle vines.
They grow on the bricks of our Mawman and Pawpa's house. They are Pop's parents and don't speak
English and live in Baton Rouge. Mom's parents are Mother Dear and Daddy Charlie. Mother Dear
lives in New Orleans East. Daddy Charlie lives in the next world.

2

Pawpa's name is Rashid. But I don't know what Rashid means.
I always forget what Mawman's name is. It starts with an S.

•

Mawman breaks dill from outside stirs it into the yogurt and puts saffron in the rice. When I act silly
she laughs and slaps my wrist with her hand. It doesn't hurt though.

•

Pawpa puts ice cubes in a glass of Coke and salts cucumber slices and puts them on a plate for me.
When I kiss his cheeks the short hairs on them scratch my face. His kisses are wet and I like the smell
of his aftershave. My hands barely reach the plate. My feet do not touch the floor.

•

I put my head down my shirt and when I stick my face back out I am a fox. Until the sun finds me.
Then I'm dead. My ghost drives a fast car. I put both my hands on the wall and the wall is cold like
water through paper. I could push my whole body through the wood but I don't want to.

•

In my chest is a pomegranate made out of muscle and a small lion.
Parts of my pieces probably don't grow in me but in the heads of little mice because when I see them
there is a lightning bridge between us that we walk back and forth between our tiny and invisible
skulls. We are so powerful the owls eat us to fly.
We can see in the dark.

•

Last night there was a scratching somewhere on the inside of my chest and when I woke up I felt a
tiger's warm breath on me but when I woke up again I saw a pale deer waiting on the grass outside

3

the window. The grass looked silver and when I stared into the deer's face her eyes reflected back a harp. Every bird in the world had gathered in the backyard and part of the earth had lifted like a door in the ground and I could see a staircase and the birds were walking down it into an underground kingdom. The deer stood still, looking at me. She gave me her back, waited for me to take it. I climbed out the window and as we rode down into the underworld, I felt myself becoming a bird with the rest of them.

•

When I stare out the car window and see someone I don't know sometimes I get a feeling like I want to touch their ear or shoulder, like I am made scared for them and even though I don't know them and don't know if they are scared everyone is scared aren't they at least sometimes? And I think that even if they don't know me maybe their cheek touching my fingers would make us both feel more still, even if we didn't know how much we were moving. Like when we turn on our street and I can see the porch light on, waiting for me. For me. When I feel like this, I feel like the streetlamps when it's raining. And I feel little. Not because my body is small but because I am putting every person I see in me and it's all a little too much to hold inside.

•

Sometimes when the streetcar turns a corner, sparks shoot out where it touches the wire.

•

My second favorite smell is my bag of Halloween candy. One Halloween I wanted to dress up as a goblin with pointy ears and Pop brought home the wrong ears that were big but just round and I didn't want them but I didn't say anything and felt bad that Pop tried and got it wrong and felt bad for feeling bad. Now I like dressing up like a hobo. They ride on trains with their clothes tied in a handkerchief over their shoulders. I put on a cap like my grandfather's and put paint on my face to look like I need to shave.

4

•

Shokufeh also listens to the Beastie Boys. I don't think they're beautiful.
But I do like that song Brass Monkey.

•

The library is only two blocks from the house. The train tracks are in the other direction. Too far to walk by myself but close enough to hear. On the other side of the train is the levee and on the other side of the levee is the river. I don't know what the train or the levee or the river says when they talk but I understand it because my body says something back. My heart speaks to my head in a morse code. The universe speaks to my heart in a morse code to morse code. The stars are the buttons the universe pushes in on its walkie-talkie. My ears don't hear the beeps but my body does. It says something that sounds like a flying flock of birds changing their minds together and turning like a blanket being held by the wind.

•

We get walkie-talkies and I have to push a button so my sister can hear me and I have to let go of the button so I can hear her and we can use them to talk through the walls and I can hear her even if she's in the house and I walk down the block even though it starts cutting up the farther I go until all I can hear is static and if I push the button down to say something I don't know if anyone hears it.

•

Tina Turner I *do* think is beautiful. Or magic. Or something else. I don't know if I know what she is. I wonder sometimes if she is even human. She's like a lion dressed up as a person.

•

The sky is the color of an orange and a rose. The petals me and my sister chew are little like me. They taste of honey and warm evenings.

•

When Mawman and Pawpa move to Virginia, I ride the train with them. I don't speak persian. We sit quietly together. From the window I see places I have never seen before. Pawpa walks me through the cars and buys me a pack of tiny donuts covered in powdered sugar.

•

I love the trains. At night the boxcars move their bodies from one corner of the country to the other. I can hear them not far from the house. Their wheels clang and there is a bell in their bodies ringing. Like they are singing to me. The tugboats and the barges float down the Mississippi. I hear them talking to the stars with their foghorns. They are singing to me too. It is a low bellow. Deep like the fruitbowls of both my grandmothers.

•

We steal fruit out of Mawman's hands and from the branches hanging over the wall. Drink melting snow out the blossoms. Hurricane season comes and the wind washes mud from our early hearts and leaves our leaves wet and green. We breathe through large soft emeralds, tune the radio to just above the stations and listen to the grandparents we don't know sing through the static. They are buried somewhere under Saturn's breakfast table.

•

I stay up until dawn and watch the phantoms funnel through the sky & into the sun. One day when my body is put into the body of the earth the earth will lift me to the sky's mouth like a bright flower. I tell Ma I am going to read every book but really I am eating them. I love them too much to only use my eyes.

•

These are things I know:
I know my zip code.
I know Australia is a far and wild place.
I know the moon is big.
I know in the National Geographic Magazine there are naked women.
I know there are women who stretch their necks closer to God using rings of gold.
There are leaves big like animal ears that catch green and heavy rain.
There are tiny blue frogs with bright red spots and skin filled with poison.
I know the fastest animal is a bird.
And that the most ferocious animal is small like me.
And that the biggest animal that ever was is not a dinosaur.
That 28.8888889 of me can fit inside a blue whale's heart.
That if I were sleeping two miles from the ocean I could still hear its heartbeat.
I know the dinosaur is a magic that actually happened.
I don't know how the fossils tell us their secrets.
But I know they do.
I don't know how the airplane flies but I know that it does.
In this way the the dinosaurs and the airplanes are the same thing.
Are cut from the same cloth.
I know some people say this sometimes
—cut from the same cloth—
and I wonder if the night sky is that cloth.
Because I don't know how watching the stars not move
makes my body feel like it was on fire with strong flames
but it does. As if I was the star shaped piece cut out
of the dark sky's fabric to let light pour in.
Both of us move without moving
Both of us on fire but not on fire.
I know the American Indians call the sky at nighttime Grandfather's Breath.
I know that Grandfather's breath plays the whistle in my chest.

I know the Milky Way is blown from Grandfather's lungs.
His breath fans the flames burning but not burning in me.

•

Me and Samandar pull Japanese plums off the neighbor's tree. They are the size of a fat walnut with a seed the size of a fat acorn. We lick our palms and dress our fingers in their orange skins. Every house has a neighbor with a tree and every tree reaches over the walls. We stain our shirts with their juice. We eat until our bellies hurt. Me and Sam we are the same color as each other. Both of us have a black mom and a persian dad. Both of us are small and skinny and brown. But when we sit in the branches it is like we are gods of something.

•

My third favorite smell is coffee. Pop calls it chicory.
When we go to the bakery in the French Quarter Mom will pour a little bit of coffee into my glass of milk and it turns the color of my skin. I don't like milk but I like the taste of coffee. Sweet coffee. At my grandparents Mawman takes a sugar cube and dunks it in her cup of tea and then sucks the tea out so it's extra sweet. There is always a bowl of nabat on the tea tray. It's like rock candy but persian. It looks like crystals. It goes in the tea but I always sneak extra pieces of it to suck on. Mom says I eat so many sweets I'm gonna one of these days sweat sugar and if I don't watch it a horse is gonna lick my neck but I don't know about that and I also don't know if she's just joking or just telling the truth but where would a horse even come from in this part of town.

•

There's a kid on the playground who when she puts two fingers in her mouth makes the loudest whistle ever. I don't know how she does it. I can't even whistle without my fingers. I don't know what my mouth is supposed to do. But I heard someone tell me everyone can learn how to whistle. So I keep trying.

•

Us half black boys on the block there are six of us. Three sets of brothers:
Me and Nays. Samandar and Andalib. Jalal and Payam. We have no backboards.
The blacker boys build their own with the telephone pole. They nail a milk crate
into the trunk with the bottom punched out. We throw the football instead.

•

To throw a spiral you put your fingers between the white notches on the football.
7 points for running it from our driveway to where the abandoned gas station starts. We abandon our
lives in its weeds and are baptized in rust. On the other corner the laundromat is painted turquoise
and pink and spits out hot air. Beside the register are Now'n'Laters, jumbo pickles, and jars of pigs
feet. When Mom yells from the front door we have to go set the table. Inside the house it smells like
onions cooking.

•

In winter New Orleans at night is the color of dark rivers and black earth. In summer the sky is the
blood of a red plum then turns into the skin of a purple one.

•

There is no air conditioner in my bedroom only a window with a screen. The cicadas turn the night
into a jukebox. I scratch the jukebox open, with my finger curved like the fishhook. Stars spill out.
I scratch open my mosquito bites. The stars tumble into the holes. I watch my blood turn red in the
air. It's hard but I try to sit patient while it scabs, waiting for my blood to darken.

•

Night after night I watch the dirty moonbeams unfold themselves in front of the bucket. They peel
off layers of dirty skin and rub themselves clean. I saw them see me, flipping back their eyelids with

9

the tips of their finger. I screamed, all that perfect light entering me with no way to exit except through the hole of my mouth. When I dream, the squirrels come and hide their acorns in me.

•

At night the backyard is the jaw of a big and black cat swallowing the sun with the bluest tongue. I am small and I grow smaller when the black cat stares my way. I get scared it will swallow me and scared it will leave me alone. I want to swim deep in the big cat's dark belly. I sleep next to the broken driveway. In the evening it becomes a river of blue cement. Under the pale moonlight me and the rocks are closer to the same color. A color somewhere between night and the ocean. When the stars hurl themselves at the earth, I am the only one on the block awake to see this. When the moon goes behind a cloud in this part of the city, I get to be dark as everyone else.

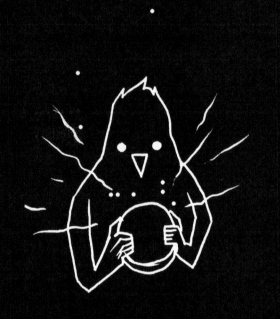

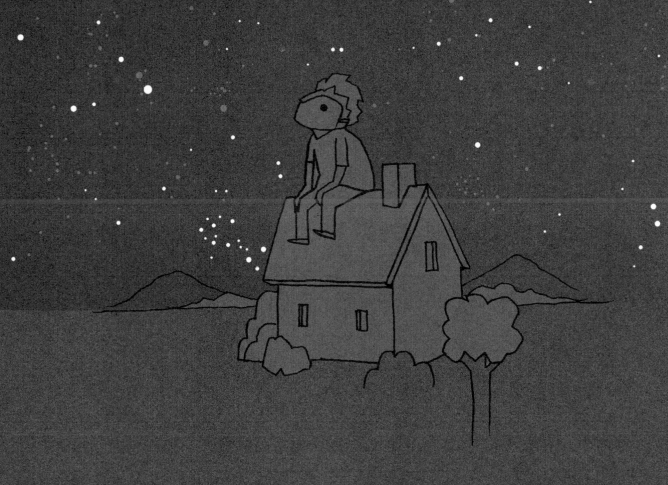

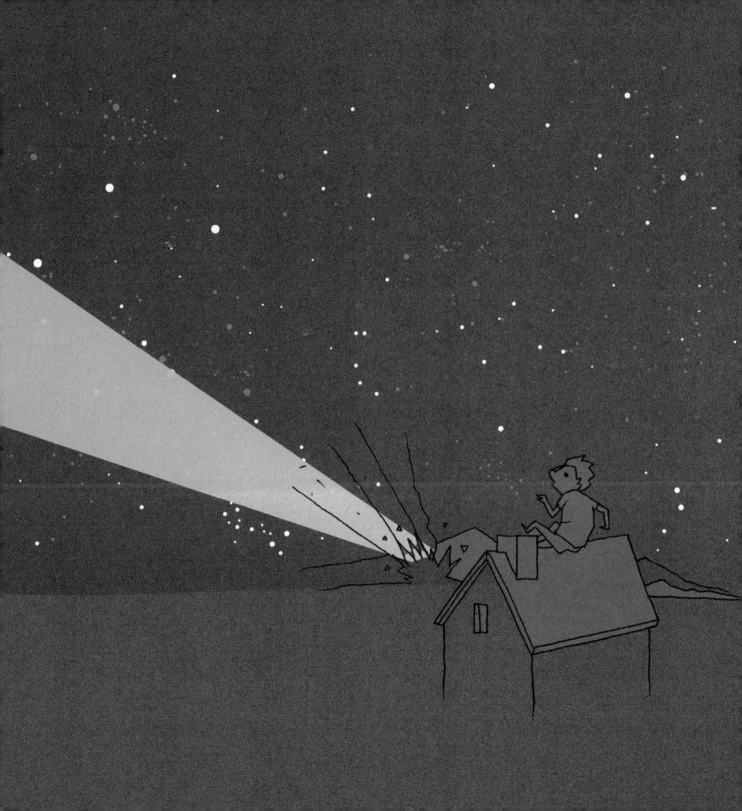

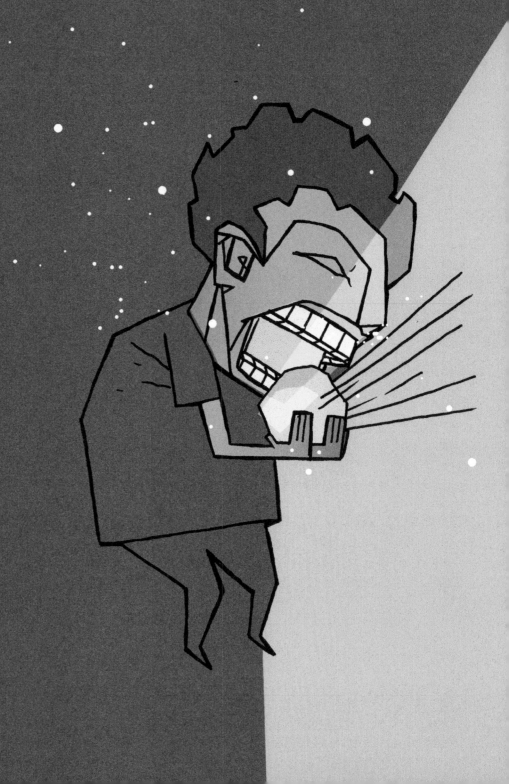

In windowless houses the night sat naked and proud
on the surface of every other body in its rooms. You
wore long sleeves & cautiously stood in the doorways
hungry for invitation inside. The thickness of the bass
was a reminder of how thin you were, how dark you are not,
which side of the light you most resemble. You didn't eat
greens. Never liked a grit, smelled bacon frying in the kitchen
but did not bite, avoided the fat, swallowed potatoes whole.
Ma bought pork rinds at the gas station. You turned them down.
Drew circles in the corse pebbles with your shoes, begged
the earth for apples. Begged the earth for weight. A bigger shadow.
Too small you used two telephone books to reach the table
at dinnertime, pushed cotton into your ears to hide your name,
the harsh sounds of its letters. You hid both parts of yourself under
the other. Dressed your mother's cousins in absence. Absence
carried a more familiar scent than family. The dark dogs smelled
the fear in you. You never said the word. Didn't know what
you were. A barrel of salted pork. Or just the water it brined itself in.
When everyone was sleeping you sleptwalk to the stove.
Lifted the pot of silver vinegar to pour out back,
to try & catch a nightingale or a haint.
Both were the same transparency as you,
the color of night passing through.

Last night I caught a star in the yard. Everyone on the block slept through it but I heard it crash in the yard and went to find it. Its skin left my hands smelling like rain and my electric race car when it gets hot. The smell of something familiar but gone. My aunt's suntan lotion. The pool's chlorine. My sister's shampoo leaving a room.

•

My cousin and me put all the grapes in our mouth at the same time. Like hot pebbles crammed in our mouth to say better things with difficult shapes. Whisper things with body but no language.

•

Gale is a word I learn that means wind and when I say it, it feels the feeling in my body, what I can only see when I close my eyes. It's like when I use Mom's headphones to listen to Sgt. Pepper. The headphones are bigger than my hands. They cover all of my ear like Radar on MASH and the cable curls like my hair. I close my eyes and something comes closer. When I open them whatever was coming closer is gone. When I close them it is dark until something darker passes by. I don't know why. But no one can tell me not to listen to what the inside of my body becomes when I listen to it.

•

Some nights I wake up and can't move. It's like I'm swimming through wet concrete. I think I am remembering my heart from before I was born.

•

Mom comes indoors from where the indigo has been burning.
The ink of the earth stains the tops of her shoes. She uses her thumb to wipe them clean and leaves on the floor the switches of her childhood, unfolds the socks from her feet. Her legs shine like a dark smooth vase. She presses me to her chest like her heart was an iron.
And the heat of the thrushes that bunch up under her skin un-wrinkle us both.

•

Somebody pulls up the tree we planted for my brother. We plant another. And Mom goes next door.
The old white lady who lives there always looks sharp at us. Mom is angrier than I ever seen her.
Orange eyes. Flames. I watch from our curtains and hear Ma say through the screen door *I planted
another tree and nothing better happen to this one.* And I hear the old lady say like a witch
*What you want to plant a tree for anyway?* And Ma says *It doesn't matter why.
It was my tree. MY TREE. And you best not touch this one*
and starts walking back to the house.

And just like the birds that breathe in the fire of my mother's breast, I scatter from the window before
she walks through the door. My mother is a pistol.

•

Mom puts me in the backseat. There is a snake that wraps around the whole earth and I read of how
on the last day, the snake will squeeze. Right now I am bigger than the snake. I sit like Saturn with it
around me like Saturn's cosmic hula hoop and touch the tips of my fingers to the snakeskin ring. It
feels smooth as milk and is black as the lava stone next to the tub that Mom uses to clean our feet. No
one sees the snake but me.

Outside the window fly by fields of crops and I ask what those things in the bushes are that look like
the bodies of white birds. Mom says Cotton.

I ask Mom if she has grandparents. She says yes. I ask what did they do. She says her Daddy Luther
which is what she called her grandfather worked at the train yard and her grandmother who she called
Mama worked in the school's cafeteria. I ask why she called her grandmother mama when Mother
Dear is her mother. She says *Because I grew up part of the time with her and Daddy Luther in Hattiesburg, so
she was sort of like a mother to me.* I ask why she grew up part of the time there and she says she doesn't
know. I ask if her grandparents had grandparents. She says yes. I ask and what did they do. They were
probably slaves she says, but that she doesn't rightly know. Outside the cotton fields turn into stalks
of sugarcane.

•

I stand in the doorway of Mother Dear's bedroom. She sits on the edge of the bed. Her skin is the color of a table made out a burnt tree. Outside the house I saw one red cardinal and in the driveway a chicken scratching. The chicken had feathers like a pigeon. Mother Dear smiles says *Chile come give your Mother Dear a hug.* I am a little afraid of her. She smells like cigarettes. I know she loves me but I never see her. I let her hold me. I kiss her shoulder. It is smooth like a chess piece. I sit on the bed and listen to her and Mom talk. She grabs her lighter from the dresser. The sheet on the bed is yellow with brown flowers.

•

In the car I roll down the window. I pretend the handle is the handle on of those old cars and I make the sound of a car starting. But only loud enough for me to hear. We pass the sugarcane again. My arm hangs out the window. The wind is warm. The wind moves through it like a flock of birds. At the market in the French Quarter they cut the sugarcane with a machete and sell it for a dollar. You can get them to cut that into 25 cent pieces. Sometimes my teacher brings in a brown bag full of green quarters to give to us. The cicadas are singing. They always are. *When they leave, you gone miss them* Mother Dear said. Mom agrees. When we get home it will be almost dark and almost dinner and almost bath and almost bedtime. Summer is spent tossing around, looking for the cool part of the bed to sleep on.

•

After the sun has pulled on a black shirt the streetlights are metronomes. I read in the backseat of the Toyota and Pop tells me not to strain my eyes and I say I'm not but I keep reading because something is going to happen. The lights on the highway are orange and bright against the dark sky. Through the car window they look like planets. The shadows move across the backseat, so smooth it's like they're being pulled on a string. When we drive beside the river and the levee rises out of the night, I stare out the back window and watch the radio towers climb out of the black riverbank. I count the red lights on them *1-2-3* going off and on, transmitting their silence into the dark sky. The sky is the color of the bottom of heaven sleeping. A blue the color of water filling a bucket of night.

- 

I flex my heart like a muscleman and radio bone songs into the clouds.
The rain returns me to where I never left. My life grows in a country I never leave.
I open a cellar door and catch arctic birds flying out, and crash through different parts of my living.

- 

The sounds my heart makes that my ears don't hear go into the sky like the radio's red lights. My heart sends itself into the clouds like the radio waves I read about. Its songs bounce around in them and then return with the rain. I wonder if my heart falls on parts of the earth I've never been too. Or if parts of my heart won't come back down until I am an old man? Then in many years rainwater made of me will fall on me. I'll kiss my own ear. And drink from my elbow. I use it like a time machine and hide myself inside myself.

- 

Our bathtub has feet and broken paint. On the edge of the tub, in the corner, is a bowl of wax and a rock of black lava. The sink has one hot faucet and one cold one. On Saturdays, my job is to clean the sink. There are three skinny holes in the center of it. I use a toothbrush to clean them. The window looks like wrinkled marbles or a map made of glass. When it's warm outside the geckos crawl across it. Their skin is so thin I can see their insides, can see their blood, their tiny tiny purple heart pump. I watch and listen to when I take my bath below them.

- 

The cicadas talk real loud. It being so dark that if they didn't speak up they wouldn't even know where each other were, and with the window open I can hear em even louder. Cicada is Latin for tree cricket. They call Latin a dead language. I memorize some of its words so in case I meet some dead people they'll know what I'm trying to say to them cuz it's hard enough trying to get people who are alive to understand what I'm trying to say sometimes and I wonder what it's like for dead people. Pretty sure it's hard for them to get folks that are alive to understand what they're trying to say too.

•

Mom holds the corners of her striped apron like she was picking blueberries but instead the apron
is filled with earth and worms. The worms writhe in the black dirt. The stripes are blue and faded.
Mom teaches me the worms are good for the soil and what's good for the soil is good for the garden.
The soil is black on her brown skin. She wipes the dirt from her hands across her leg and sings under
her breath
*your house is on fire*
*your children are all gone*
and pulls a ladybug out of my hair.

•

We go to Mark's dad's cabin on the other side of the lake and go to the canyon with a rifle.
When I shoot the .22 it is like an invisible man pushing me back. The styrofoam plates are peppered
with holes and the red stones littered with shells. On the way home we stop at his grandmother's.
From under the palm trees I watch them play kill the man with the ball. Everyone except me is white.
white. Even though I already always say thank you, I make sure I am on my best behavior. I can feel
the wind using my skin to try and say to me my name.

•

Our feet grow fast and sometimes we get new shoes while they still fit.

•

Mercury is the perfect skipping stone, small enough to fit in my palm.
Vulcan is an invisible planet and loves Venus.
Venus is a green apple everyone wants but no one can pick. Sunlight entering Mom's pupils.
Earth is a conch shell I lift to my ear. A turtle shell I crawl inside of.
Mars carves cat faces out of wood and steals your biggest marble, gives it back on your birthday.
Jupiter is bigger than your biggest marble.

34

Saturn wears a hula hoop held by an old man. I hide my body inside his body.
Uranus is how some people say my name. They are wrong. Uranus carved the stars for his Earth.
Pluto is a plum, purpled to where it cannot be eaten. But is the prettiest color of the thickest summer.

•

On the far side of the clouds 12 kings are pulling out their wings.
I run through the yard to catch the feathers.

•

My grandmother teaches me by me watching her hands closely, how like a bird's and delicate they
were, and a gold bracelet always on her wrist decorated all over with a pattern of leaves.
When I am older and she dies I will ask for a tube of her lipstick.

•

I had a dream where I was older and I ate cooked meat served to me on a sword.
My brother was gonna get married beside an ocean and I fell asleep in a chair beside a fire pit.
My body made my brain dream of the ocean because it knew it was what my heart needed.
Except my heart had been so hungry for light it ate all day long and once night came it couldn't keep
its eyes open. My heart slept through the whole thing.

The light showed itself in several different forms. A fat and bleeding sun. The fur behind a tiger's
ears. Grandfather breathing across the night spilling milk in the stars. When my back was turned he
laughed and gave me more apples. I felt the sun eating me in reverse.

•

In the dream I was under a big carpet hiding from the things inside me that try to find me.
The morning rain traveled down to the garden's deaf petals. The past and the future sat in the same
seat at the same time, only the table was changing. I was me and a grownup at the same time.

When the TV is turned off the TV show stays on. Somewhere inside the transmission I exist with the knowledge of where I will sit. Tulips in a northern city far west of where I have ever walked.
The cherry blossoms speaking in several tongues both after and before they met me.
Sharing a scarf with the wind. Swimming in a big deep hole filled with the earth's water.
Falling asleep beside a pit filled with flames.

When I woke up I was scared to look at a mirror. It felt like I would have a different face that was still my face. Like it would be stranger except I would recognize him. It is like in a dream when you see someone and they don't look like your father but you know it is. In the dream, Grandfather, on the inside, was really the dark sky, was all of space. And I told him I want my heart to be stapled in the softest fabric the universe has. A cloud made of horse hair.
I tell him, I want people to want to touch my heart.

In the dark when I wake up I put my hand on my chest, over the place where my heart is.
No matter how much I rub my hand I feel like I am holding a rock and I am wearing mittens.
I keep trying to touch its smoothness and I can't.

•

My heart is a bird of soft colors & dark eyes. When it uses its beak to clean its feathers it looks up and stares at people longingly. Sometimes my heart reaches. Sometimes it pushes back.
Somehow it sometimes does this with the same motion.

Every night I pray for a lantern in my chest. I pray the lantern be big. To follow it through myself and over the hills. Some nights are foggy. Some mornings I can't make my face out at all.

*Before the return to particle. The star*
*as a conduit for the heart. Your body a small synonym for both.*
*For space. For Mercury & Mars. For love.*
*& for all you place your shape into? & for what is Black?*
*Because the brightest parts of you talk loudest at night?*
*& because when in the sun you sometimes swallow what of you is visible?*
*The bookstores become but one place to hide inside of.*
*The clothing racks of the department store.*
*The jokes strung between you & your cousin.*
*The small galaxy beneath the grocery cart keeping you close to the earth.*
*The music that lifts your feet above your spine.*
*& why does one side of the spoon reflect you upside down?*
*& why do Antarctica & Australia & Russia seem stitched out of the same wild cloth?*
*& the dark birds stepping out of the dusk into your skull? Their footprints left in the dew?*
*You the son of a czar hiding a clockwork heart inside the blood filled bellies of the wolf's pups.*

*How the telephone works, how the airplane flies does not have to be explained.*
*But even in the understanding of their science, there are bolts of magic.*
*When you hear the river & the train both singing at midnight you know your real name*
*& that it carries no letters. Billy's mad jazz comet*
*birthing peace through his cornet. The shade of the magnolia, its velvet skin.*
*Jasmine scenting your mother's neck like a necklace of pearls the sky strings only for her.*
*Everybody knows how to whistle—Virginia teaches you this*
*You see in your sleep a crippled ironsmith, bending your shape under gold fists.*
*The clamor of hammers banging on your body creating showers of sparks*
*when pressed under the song. The dark birds stepping out of the dusk into your skull*
*Leaving footprints in the evening dew. The singing at midnight of dark & beasting geometry.*
*Waking unsure if the night's dreams were memories of the past or of the future.*
*How the rain on your neck feels like a language slipping out of both these places*
*When you listened to the river & heard the train you knew your real name.*

My heart is a switchblade being opened. In a room with the lights off,
my hands don't know which end is the bottom and which end will cut me.
My heart is a lake at night. The moon drowns in it.
The fish come to the top to feed of the light. The lake wonders if it is sky. It is confusing.
My heart is my father. It will call on the way home.
Will end the call with sweetheart. Will help birth me. I have its eyes.
A wolf is holding my heart in its mouth.
I don't know if I am being carried or being eaten. But somehow I will feed some part of him.

•

Down in my heart there is a rooftop that touches God from the bottom up. There is a short well that echoes beautifully deep. There is another heart that tries hard. There is another heart other than this one that tries harder. There is a third heart sometimes under the first two sometimes on top that does not try at all. All three hearts change size depending on the color of the week There is a radio that tries hardest. To talk back to the stars. To pick up a further sound. There is a photo of a memory trying. To pull itself back together through the static. Is a photo of my father when he was younger than me. Is a castle. For every face I ever seen. Is a conspirator with the dawn to make me better than I was the day before. Is a lantern swinging on a windless night. A flock of birds. Of meadowlarks! That like Mom says, are splitting the evening with song. Flying like one body made out of many small bodies. Falling apart like the night in the blue arms of the sun waking up and then returning at dusk. Warm and heavy. To hold all the earth close.

•

Uncle Morris had a stroke. Mom some days shakes her head at how much I swing my arms like her brother. Mom's Uncle Bo has a mustache and a round belly. He's her uncle but is more like a brother from when she was my age and lived in Hattiesburg with him and Jesse and her Mama and her Daddy Luther. Mom told me she loved reading so much she would Uncle Bo's science textbooks. They lived on the colored side of the tracks. Daddy Luther changed the train cars there. In New Orleans Daddy Charlie swept them. Mom took me to Hattiesburg once. There is only a tree where she once slept. The church they prayed in is the same size of my bedroom.

•

My heart twists like a hurricane and sometimes I can't breathe. It twists like my sheets. I don't know the names of my black cousins. Don't even know their faces. We leave Louisiana in the summertime, drive to Virginia. Stay with Mawman and Pawpa. With Ameh Jaleh and Amu Farhang. Sleep over at my cousin Meisa's. Ameh means aunt, amu means uncle. Meisa is spanish for table but she hates that. I ain't never slept over at Aunt Lynette's, never ate any of Dennis' cornbread cooked in the iron pan. From the highway I look at the duckweed blanketing the wetlands. It looks like I could walk on top of it, wouldn't even sink, even though underneath I know it's marshwater.

•

I am black water. A heavy stack of wet paper drying. Browning in the air. Turning white in the morning. A knife in the drawer. Pocketknife in my pocket trying to cut a song while still folded in the dark. I search for stones to sharpen it with.

•

I used to be afraid of the swimming pool. Then I turned into a fish.
I used to be afraid of the eyes of white light staring at the beach. Then I turned into a blind man.
I am still afraid of the dark. I am afraid that if I walk through it, I will disappear.

•

If you ride your bike fast as you can and hit the brakes you can leave a black mark on the sidewalk, like spirits were talking out loud. The longer the mark, the more they say and the bigger I feel. The first time I don't fall over when Pop lets got of the back of my bike seat, I feel like if God had a candy store, I'd be walking through it.

•

Talking to God is easy. You fold your arms and close your eyes. But I don't know what is supposed to

happen then. Sometimes it is hard to just be quiet. But sometimes the quiet feels nice.

•

We find a box of donuts in the street. I eat the ones without grass on them and make Sam promise
not to tell my mom. In his driveway is a broken chandelier. It has clear stones that look like diamonds
hanging from it. They are plastic but when you hold them up, they make rainbows in our hands.
With the light passing through them we rule the country.

•

There is a big storm and the power goes out. We eat dinner and play cards by candlelight. When I
go to the bathroom I carry a candle down the hallway. Outside the wind makes the trees creak like a
floor. I cup one hand around the candle's flame like it was a baby bird that needed me.

•

I wait for summer to come. I spend hours in the tub. I am trying to hold my breath longer.
My fingers turn to pink prunes. I go to bed and wake up in the garden with my mouth full of dirt
and my fists clenched around leaves trying to bury them.
I don't remember what I was dreaming about.

•

When Mom puts us to bed, she reads out loud to us before lights out. She reads to us and sometimes
we read to her, and then we say our prayers, and Mom lights a lamp in our chest and floats us down
the river that runs between this world and the other.

•

It gets so hot at night sometimes I leave the window open and there's lots of mosquitoes outside but
there's a screen on the window so they can't get inside even though somehow they sometimes still do

and when they do they drink me all night long and the sheets make me sweat so I kick them off but then I get cold so I pull them back up and sometimes I do this all for what feels like forever trying to get comfortable but I found out if I have my sheet over my body but not my arms and not my feet this feels cool and pretty good even though it makes my feet feel like something could come through the window and eat them even though that screen is on the window but since there's a mosquito bugging my ear we all know how much good that thing seems to sometimes do.

•

At night the buildings are all dark shapes. The darkness makes them blend together into one thing. They do not look like buildings. They could be anything and nothing. At the same time. I think this might be a magic thing.

•

I wave my hands at the world when it passes past to remind it I am here. Sometimes when I wave my hands the rest of my body feels like a whisper. I become a secret waiting to be shared. I hear frogs singing it to the darkness. The trees move to their song. All the night knows the secret of my heart. It all makes me feel like the stars, large but far enough away to seem small. Like telescopes are looking at me while I look through them. My body a balloon rising out of water.

•

There are flowers that open only after the sun sets, after the dark comes. I wonder if they are sometimes scared by the bright eyes of the day. I know this feeling. Crocus. Cereus. Night blooming jasmine. My mother's favorite. She walks on to the porch and says to its fragrance *Good evening Night-Blooming Jasmine* and breathes deeply. I wonder if Mom, even though she is loud as the sun, knows the feeling too.

•

I read about a flower that only opens every hundred years. It is the color of fire and it blooms for one

night and then dies. The phoenix is a bird with feathers made of flames and she lives for a hundred years then goes to sleep and her dreams set her body on fire and then she is born again. The fire flower is like the phoenix except in reverse. They both feel sad but also powerful. This too, I think might be a magic thing.

•

When I hear the trains at night moving outside my window in the near distance I feel how looking at the stars makes me feel. Like I am maybe made of a song that only just then found a mouth to move out of.

•

Sometimes after lights out, we hold flashlights up under the sheet to keep reading. Sometimes I read by the light of the other room leaking into mine and when my parents walk past I put the book down and close my eyes and pretend to be asleep but I think they know what I'm doing. They always know what I think they never do. If you put your finger in your mouth and push it across the inside of your cheek when it flies out your mouth it makes a loud popping sound. When I showed Pop this he started plucking his fingers across his throat like it was a xylophone. I couldn't do that. I tried! It only hurt. That is what I mean by them knowing things. So I bet they know I am reading when I should be sleeping. I think they know because they used to do this when they were my age and their parents were walking down the hall pretending also not to know this! And maybe the same when their parents were our age and their parents and their parents! All of us at some point the same age and doing the same thing! This is definitely a something of magic.

•

I like it best when the whole house is sleeping except me. Then I turn the lamp on and pull out all the books from the shelves, fill my bed with them, and read until I can't anymore. My eyes get so tired, my body so full, it has to sleep so it can talk to itself. On nights like these, I fall asleep with the light on. This also is magic. Not like the phoenix flower and not like the stars and the trains or all of us the same age but all those stories stacked in my lap and the world not moving and me getting to

44

read them by myself, all those stories just for me. This must be some kind of big magic I think.

•

I dream of flying high over the house. I can see the trees and the rooftops and a wide river. I dream all night long. I fly kites of gold silk. A circle of beautiful girls see me and I run towards the flowers. An old man makes records under the earth. A young man feeds me a soft bird and we both cry. I talk to a boy smaller than me about a the ghost of a deer. The devil is there. So are my grandfathers. I sit in the river with them. Me and a horse dance in a garden of snakes.

Pop says to conquer your fears. I fear snakes. So I dance with them. I hold their invisible arms around me. I am outlined with light. And there is a strange color to the light. I hear Mom singing in the dream. And also in the dream Mom is washing her hands, inside my heart. And she looks up but I don't think she sees me. Her eyes shine like bright stones in an ocean. This is the light I am outlined in. And then Mom wakes me. The light enters my eyes and I hear the teapot just beginning to whistle.

•

While my pants are warming up, Mom always asks if I had any dreams. I say yes I dreamed I was flying over the house and in the dream she was there, washing her hands in the sink but the sink was something else.

•

Mom puts newspaper on the bathroom floor and sits us on the stool one by one. She cuts my hair. I get scared Mom will cut my ears but she never does. My hair doesn't do anything right. It's less curly than the kids darker than me, more curly than the kids lighter. My hair gets even more curly when it's hot. But it still doesn't have a clue what to do on the top of my head. It curls like Mom's hair and is soft like Pop's. Pop says he fed us all watermelon seeds when we were babies and then vines but no melons grew out of our heads. Pop says when he was a boy they would sleep on the roof of his house in the summer and would eat watermelon all night long. I wish the roof of our house was flat like the ones in Iran.

45

•

Mom gathers my curls. She takes them into the yard and like in one of the books she reads us, throws them to the birds. The birds come and carry my hair off to make nests out of it.

•

The birds love Mom's hair. They come to her and sing when she smiles.
In the kitchen while she cooks dinner she sings out loud. She has the television on and when the news makes her mad she yells at it.

•

Pop comes home swinging a lantern on the end of a stick. His briefcase is filled with gold. Until he opens it, then it turns all into office papers. It's a trick. The moths follow behind him to try and circle the light.

•

On Saturdays Pop falls asleep on the sofa and I, softly so he doesn't wake up,
hold his head from the top in both my hands and kiss his forehead. He starts to snore.
I hug his skull and every bird that flies out of his mouth I swallow with salt and pepper. Bird after bird and after bird after bird. I catch every single one in my mouth. Pops doesn't wake up at all. I laugh my way up the chimney and into the attic with a story for the silk webs and become a smiling ghost.

•

The spirits come to me when I think I must be asleep. But I must not be.
They carry me through the timbers. And between the tall stalks of the vegetables Mom is growing.
Me and the spirits we stole tomatoes from out the silver coated garden. We danced while the tornadoes were sleeping. Under the dark and beautiful face of the one-eyed night the moon blind and too bright to blink, closed.

*We folded the blades & cut our thumbs.*
*In the corner where the bamboo eventually came.*

*Walked into the dark triangle with 13 flashlights*
*all flicked on & burning & costumed in*
*the sheets pulled from the bed to bury the book*
*while wearing arrowheads of face paint.*

*Like a tribe that went missing on purpose,*
*to lose itself on the far side of Mars & stay in the red hills*
*to better watch the skeleton of the celestial.*

*To see the pulleys & strings of the world.*

*To see the hairs on the other side of its theatre.*

*To listen more closely to the little skulls of stars*
*using the bone as the pillow that the animals would return*
*to climb beneath our skin, licking our hearts from the inside.*

*Lipstick across our cheek. Mascara on our brows.*
*The feathers of bluejays fallen taped to our wrists.*

Our parents smiling from the window, with the wind
pretending to be cold so we might think another planet
was under our feet & that the hole we were
placing the book into was a tunnel going back home

& the book—our hearts, words placed in foreign earth,
not just for safekeeping but for transmitting the life
of our small adventures back to the old neighborhood—
who would assuredly miss us, would most likely be
stamping postcards for Saturn's gold wings, believing that
that must have been where we had been charting ourselves for,
back when they spied us bending boxes of cardboard, drawing
on them dials & video screens. Using fat brushes to paint
the machinery of imagination, pouring pictures into the maps
we drew of where we were going.

The compass of our dreams leaving us wet & curious
in the marble cold morning. The fog clinging to the trees
to make sure we arrived safely back in the real world.
but with the dreams still intact. Taking them to school, hidden
in our pockets like a cricket. Like a hollowed acorn, a rock
shaped like a heart carried to others for show n tell.
A dog-eared football card of the Raiders,
The coin from China with the square hole in it.
The striped candle you made over the fading summer.

The photograph showing what your mother looked like
before she was a mother but no longer a child
wearing a coat that must have been a spaceship
cuz her youth looked so alien to you
that she could only have been beamed in
from a distant constellation.

& you had to show the class
who you are, what you come from,
make known to them the secret of your blood,

to show how you were just as full of music
as the Union Pacific dropping down on the railway tracks
less than a mile from your bedroom window & coming on in
from San Antonio in the middle of the night singing all the way
to North Carolina & maybe even further, while you listened
to the singing of stone on stone, two hours after bedtime,
two hours til the witching hour, keeping time as you set the time
machine of paper & ink deep down in the midnight soil,

The one that would carry what you were to what you would become,
carried as a marker of where all of you had once been
& where all of us were still heading.

The grass grows over the car tires. I fall asleep in the backseat under the back window. My body twisting like one of Mom's 45s left in the daylight. The needle skips when it touches my tips. I have scratches all over my back from growing too fast. I don't know where the wasps came from. The bending sun drew them to me. Their sounds sound like my name. It hurts my ears. In me is a bird that is always and never tired and its wings are smooth as both my grandmothers' arms.

•

I know the color of tea.
The taste of milk with coffee added to it.
The smell of Pawpa's aftershave.
The smell of magnolia trees.
I know that the oak trees have a sleeping god in every one of them and that the oak tree even when asleep is always listening and that the oak trees grow so large and close they make a second ceiling of emerald light I walk under after school.
I know the walk home from school.
I know the walk from school to the bookstore.
I know I can be trusted with a housekey of my own.
I now know how to close a pocketknife without cutting my thumbs.
I know my thumbs might wish I knew that to begin with.
I know that things must happen to learn them.
I know there are things that happen when I am not around. That the TV when turned off keeps on going.
I know that what I carry home is mine mine mine.
I know that in some trashcans are treasures.
I know that some treasures are heavy when you are little, but walking them all the way home is an adventure and that even when your mother wrinkles her nose at the millionth thing you bring home out of the trash and that when you say but this thing is a television and she points out the giant crack in the back of it, that when your friend Pejman fixes it enough to get a black and white signal, Mom can't say anything about what you carry home. Ever. Again.
I know that duct tape can fix a found television.
I know the feeling of fixing.
I know the sound of breaking.
I do not know the breaking of a heart.
I do not know the fixing of hearts.
I only know what a heart is.
I know there is a thing called a kiss and that the kiss comes in many different mysteries.
I know the hotness of a summer night in the South and how the South cracks itself open to let the

rain rage and that June is the rainy season but that the night I was born the South put itself on pause
to place me in its wet hands.
I know Russia is a strange and distant place.
I know there is a bird in the throats of the Russians and when they sing the bird speaks hungry and
warbling poems.
I know the sun travels in a carriage of four horses.
I know the sun shines out the eyes of an Egyptian lion.
I know the myth of blue gods. Of Krishna as a baby and not letting go.
I know the ruler of the castle tricked Thor into making the ocean ebb.
I know Mars' real name is Aries and that he is spoiled.
I know Hermes tricked cows away from Apollo and made a turtle shell sing.
But I do not know the music.
I do not know the piano.
I do not know the guitar.
I know the violin hurts my fingers.
I don't know *the* music but I know *a* music
And how it plays and plays.
I know my sister plays her stereo loudly.
And that when she plays Joan Jett I also am in love with rock n' roll.
And also with Joan Jett.
And also with Tina Turner.
But I do not know what love is.
I know I have been practicing how to whistle for a long time
and that I tried it the whole car drive from New Orleans to Ameh's apartment building
up in Virginia and that just when we pulled into her parking lot I whistled for the first time.
And I know that I can now whistle anytime I want.
But I don't know how I am doing it.
But I know I can.
And that in my heart is a tune that Grandfather dropped out of the sky and that Pop caught it
and Mom held it and they pulled pieces of clay out of their wet hearts and made a whistle
to wrap the tune inside of and that whistle is the one in my chest
I know love is my mother kissing my forehead.

•

Sometimes I wonder what happens to the inside of my body when I sleep cuz it doesn't feel like it stays here. And I also wonder about all those dead folks and what it's like for them to leave their heart here in this world turning into dirt, while taking their love with them, to dissolve into the furthest stars and I wonder if when I arrive there if they'll even know my name or if I'll have to write it on the things inside me, in something only the dead can read. Which is why I started memorizing all those Latin words to begin with. But I don't know if words are even what people understand anymore once they're dead so I decided I needed to memorize other things too.

Like how the breast of a wood thrush and a hermit thrush are speckled kind of the same but how one of them has a rusty colored head and the other a rusty colored tail. And how turquoise is a mix of blue and green but really looks like if the sea were made out of smoke or how magenta is red and purple but really somewhere between blood and night. And how the multiples of nine are all reverses of each other. And how Zeus' mother tricked Zeus' father into eating a stone instead of Zeus. And how if I feel weird and warm in the night I can always flip my pillow and then feel better. Or how I never hear my pops say a bad word no matter how angry he is. Or how my pet mouse holds her food. And I pay attention to my back because it holds me up even though no matter how fast I try to move I can't see it which makes me wonder if all that I can't see is what's holding me up. And if all that I can't see is actually dead and balancing parts of themselves between this world and the other side of the galaxy? And if so then I wonder if the everything under my skin is dead because I can't see any of it but it still keeps me balancing and what parts of its invisibleness is here and what parts of it are breathing in the flowers growing in another part of the universe?
And if the inside of my body is in that part and the outside of my body is in this part, then what part of my body bridges them and in what world is it?
And at night when the cicadas are outside my window and I am supposed to be sleeping, why does my heart move like a blown up balloon into an empty balloon and an empty balloon into a blown up balloon, and when it fills and empties it makes a beating sound, and how can I be alive when I am also almost certain that my heart makes that sound to talk this close world of me to that far away world of me, and just when I was thinking all this with the window open because it gets so hot in New Orleans in the summertime, even at night, a horse put his head in the window and licked the back of my neck.

II.

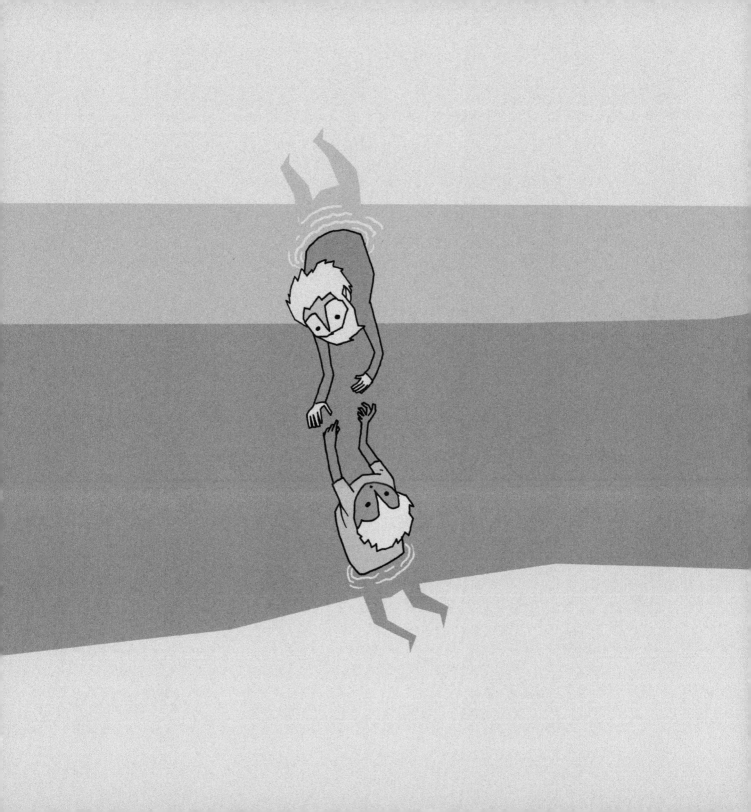

III.

The horse licked me awake. He put his face against my neck like a dog would and I let him like I wasn't afraid. I climbed out the window and onto his back. He was soft like warm water. It felt like a fire was being walked through me. The horse had wings and we flew into the air. In the moonlight I could see a river, it was green like apples. We flew over it. The moon was a white hole in the sky. The horse flew us into it and on the other side he landed down on the grass like a pillow on to a bed. The sky was like charcoal covering a stone. There was a road twisting off into the distance and far off, a large dark house. Over the hill I saw a fiery car come around the curves. It pulled up next to us and the door opened and there was a driver with a silver beard inside. Horse pushed me inside and I dreamt we started rolling towards the dark mansion.

The driver didn't say anything. Only smiled at me in the mirror. We passed a meadow and I asked him to stop. I had seen my grandfathers sleeping in bedsheets strewn across the open field. I got out the car and approached them. They were both snoring loudly. On their shoulders were bats covered in gold hair. I shook my two grandfathers awake. The bats fluttered just above their bodies, like large glowing moths. My grandfathers pulled silk strings from out the mouths of the bats and handed me one. I held it tight. The bats rose like kites and our kite strings unspooled off their tongues. I dreamt of flying kites with my grandfathers while the fiery car sat waiting. I dreamt my grandfathers took the string from my hands and tied the bats around three stones. I dreamt they took my shoes off and brought me down to the river of green apples. In the shallow part of the water they pushed my feet into the cool mud. Above us the bats had unspooled themselves further. They looked like three small stars, dancing together a strange dance.

My grandfathers led me out of the river. They kissed me and I was dry and they walked me back to the car and the man of silver hair drove me through the hills. We came to the house of this dark country and stopped and the driver opened the door so I got out. The house didn't have any doors but it had a window and I looked inside and sitting on the floor was a boy who looked just like me. He had a lamp and a stack of paper and he would shine the lamp on the paper and hold up a plate and block out a circle of light and the round shadow cast would cut a hole in the paper. But the hole was solid and he would lift it up and it looked like one of Mom's records. He put it on a record player and listened to it while he kept making more records. Then out of the other rooms in the house, poured a group of widows but before they had been married and they circled around the boy who looked just like me. And then they turned and saw me and I got scared. I could smell flowers in the dream so I

ran towards the smell.

I walked through a swamp and there was a tree that had been split by lightning. I dreamt a baby swaddled in the split trunk and the baby was God crying so loud and still nobody came and finally the blue herons had to walk through the swamp and they used their feet to put the swamp's mud on his forehead to cool the fever.

I dreamt that in the tilt of the earth the stars spilt like cream poured over the front of the blackest dress and a river of silver buttons buttoning up the back.

I dreamt the Milky Way was a man on the back of a tiger in the sky and the man was called Grandfather. I watched him scratch behind the tiger's ears and his white cloak was slipping over his shoulders.

I dreamt a man on the far side of the constellation looked like me cooking small bodies in the milk turning the batter over a fire and trying to find a way across the canyon of the night but was lost and in the dream I yelled from my side to his side and I told him that all the birds in the storm were pulling his hair out and I was so loud but I don't think he could hear me because he was crying even louder than my screaming heart.

Somewhere between the bodies of the dark house and the gardens I could smell, I dreamt a pack of dogs. I followed them. They led me through the woods and we ended up at a campsite that the stars used when on earth. The tents were still pitched but all empty and no constellations to be seen, like they had left in a hurry or like they would be back shortly. The dogs sniffed at the campfire remains. I dreamt I looked at the sky. It looked like a swept floor. I imagined the giant broom. How empty it sounded. In the dream I sat on a log. In the dream the dogs began to howl. In the dream I scratched a stick through the ashes and then joined them in the howling under the sky. How strange that for something to sound empty it has to make noise inside something else. I felt like we were pouring water down the sink of an abandoned house.

A man in a long red cloak walked out of the trees. We stopped howling and watched him. I dreamt he asked to sit with us. Me and the dogs nodded. The man told us he was a writer of operas. He had

a practice of writing an opera, then burying it and digging it up a year later. He said he was constantly writing operas and burying them. It seemed like every day a year had passed since one of his operas had been buried so he was always digging one back up to finish it. He said the time the operas spent away from him, the time they spent in the earth, allowed something to happen. He didn't know if the things that happened were him not remembering the notes fully or the earth actually changing the music he had composed. He said he felt it didn't really matter which one it was. The music was the music.

He said he had heard the water we were pouring out with our bodies and incidentally we were in the same place he had buried an opera last year. He asked if we would help him dig it up. I looked at the dogs. They said nothing. I dreamt I took a shovel from the man's outstretched hand and began lifting the ground with it. I looked over at him. He was singing softly as I shoveled. He sounded like the only canary left in the tunnel and his cloak was red as the blood of the maple tree.

I dreamt Apollo burned red the leaves of his orchards and then gave them all the rain he could carry.

I dreamt I unburied the man's opera. That it looked liked a small brass box. I dreamt he opened the box to show me what it looked like. Inside were two brown birds turning blue. They cleared their throats and started singing. It sounded like walking through a woods and hearing a creek not too far off. I sat in the hole I made and the man in the red cloak closed his brass box of birds and began filling the hole back up. I dreamt the man said *You are my opera now* and I said *Yes, and you are mine?* And he said *Yes, when next you unearth me I will be very different* and I dreamt he covered me with the ground.

I dreamt I was buried under a lemon tree for safekeeping.

I dreamt the rain was the only key to the locked box in me and then I drank all the rain.

I dreamt the inside of me was the bottom of the ocean.

I dreamt the inside of me was vast and so dark that the creatures in me had to learn new ways to see.

I dreamt I was held under the hot earth. I dreamt I was held upon the hot anvil. That the crippled lover of Venus held me in metal arms and hammered my shape. I dreamt he changed his mind about it many times. Back and forth. Back and forth I was beaten, between bow and arrow, between saddle and shoe, horse and hoof.

I dreamt my maker could not decide what he wanted me to be. Was plagued with indecision. Sat under the apples of the stars, waiting for that which might feed him to fall, forgetting he had forged the fruit inside the blue flamed heart of his own body. I dreamt my maker began to dream a dream of me dreaming.

And the dream was a dream of the future dreamt in the present to tell me my past.
And the future was a world made of small and little worlds that everyone has of their own and this world is all burnt down and walking through the ash is a man and a lady ghost and the ghost of a dog and the man sits on a tree stump and the lady ghost tries to hold him but she can't touch him and the man tries to touch the lady ghost but he can't hold her and he is crying tears because of it and every tear that hits the ground turns to steam and the lady ghost is crying ghost tears which come out as steam and when they hit the sky they turn to water so the man is very cold from all the storms the lady ghost is crying and the lady is very warm from all the heat of the man's sadness and the ghost dog is howling because the unseen things she loves are becoming only patterns of weather but since she is a ghost there is no sound out loud but I can hear it inside my chest and it sounds like yelling into a bowl except the bowl is the size of night and the yell is deep as the ocean's floor and eventually the lady ghost dissolves into the sun of another world and the ghost dog digs herself into the earth of another one beneath her paws and the man is surrounded by the steam of so many tears he is afraid he will kill himself to get away from it and he starts screaming and in all these small worlds everyone is alone on their own planet and the only one left on the man's planet is the man so I don't know how I am here or where I am or why he can't see me but because he can't he is screaming and he stands up and starts clawing at the stump he was sitting on and the bark flies through the air but also tears off his nails so the air is also filled with his blood and he starts clawing at the earth around the stump and finally uproots the whole thing but he doesn't stop he starts tearing up all the earth and tearing all the rocks and the roots up and he does this until the whole world is hanging in the air around him and there is nothing under his feet and nothing for him to stand on except for a giant hole and that's when we both see where I have been watching from.

And I remember, in the dream, the blood came out like a fountain.

And and she's saying to him *Look it's like petals* and he just nod his head and she scoops up his blood and starts feeding it back into him and it keeps coming back out around the slab of glass she had pushed in his belly and she says *I have to leave* and he asks where she's going and she says *Catching a ride out to the far away lands* and then keeps on putting the blood that she won't call blood into his mouth and he asks where the far away lands are and she just points her thumb behind her and she says *But you'll be fine* and *This is better for you* and *Believe you me it just would get bad* and I think how this seems pretty bad for him and he starts to say the same thing but she cuts him off and says *Don't be like that* and *Just keep eating these petals* and he says *But these aren't petals* and she just smiles and looks like she hurts but only a part of her like she had stepped on the wing of a bird but the rest of her looks like a hard building the bird might fly into the hardest and the smoothest metal catching light and it hurts my eyes to look at and she puts some of the man's blood into his hand and lifts the hand to his lips and stops for the briefest turn of the clock and then walks away and he swallows and in the dream he puts his hands to his blood and his hands to his mouth and he swallows the blood back down, which comes back out the hole she made and he puts the blood back in his mouth and he keep on doing this and I wonder how long he has to do this before the blood stops pouring out or he gets tired of tasting its too sweet taste and its only when looking at the footsteps that she left in the blood as she walked off do I see how the inside of his red and bright body does maybe kind of look like a flower parting itself and I think *Oh how I wish to stop eating* even though the man is the one eating, not me, and still I think *Oh how it feels like I have always maybe been eating something hollow* and *How I wish to pick up and follow for the farther far away lands or for at least as far as I can go before reaching the water that lays in the lake that lays in the place where the sun and the moon sit with the sky on the same plate at the same time and without the need to any longer parcel the light we blindingly shared between the bodies and the gardens.*

I dreamt I was somewhere blind. Was somewhere between the bodies and the gardens, somewhere between the streets and the moons, somewhere stuck between my body and my heart.

And I was surrounded by the dark shoulders of Grandfather and his tiger and I dreamt that surrounding both their dark shoulders were angels turning the fires of suns and I dreamt the suns reached to touch me and that I wanted to hold them without burning. And I hid under the wardrobe and I pulled myself out but I didn't know who I was or how big my hands were because my hands seemed so small.

And a man pulled me out of the earth like a radish.

I dreamt the man was digging a hole when he found me in the dirt. He told me he was burying a dog in the hole and that the hole needed to be the size of a house because the dog was inside a house he had to also bury. He had a lot of dirt to fill the hole back up with. I dreamt a mountain of dirt. There was another hole the man had, in the middle of his body. I dreamt water kept leaking out of it. He didn't seem to have any dirt left to fill that one up. Or maybe the mountain had come out of that hole. I don't know. In the dream neither did he. So he just turned the radio up. I recognized the song from somewhere. Maybe it is one that mom sings to us before we sleep. Yes. She sung it. Just before I came here. On a bird in the skin of the horse.

I dreamt we came in on the birds is what I told the man with the beard.

He had a beard. With birds in it.

It was woods around us. And we were in a clearing. And it looked a place of gypsies but they were gone. I dreamt the man bent over a fire breaking pieces of something into a pan. And I asked what he was doing and he said it was the hearts from the dark birds in the dark trees. But I heard birds singing in the dark trees behind us and anyway I knew already it wasn't bird hearts but her heart, even if I didn't know who she was. I dreamt the man's voice sounded like a dream deeper than what you remember and that the smell of the heart cooking seemed to be making the man cry. And the sun had sunk but night was not here yet. And there was a fog in the air. And the hills looked like they were wearing coats tailored out of ghosts and the ghosts were so quiet while watching the man cry so silently as he cooked the heart. As he turned the heart over, the man's hands looked so cold and he had holes at the shoulders of his shirt like something had been torn out his body. I dreamt a dog waiting at his feet and the dog's name was Trudy and Trudy stared at the man and Trudy's eyes were wells asking for the man to bucket himself out from Trudy's love into the cool evening. But the man could only look at the pan and the smoke rising from the pan and in the dream the man's face was the same look on mine. And I didn't know if what was making the air around us smell so good was the heart or the burning of the heart and me and the man were both so hungry. I could tell from how both of us were holding so tight our bellies, as if were we to let go our hold on them everything in us might fall into the yellow grass. I dreamt his mouth looked exactly like my mouth except maybe perhaps older more tired and I knew that he was eating this heart because whoever she was and wherever she had gone, she had taken his and he needed to put something into the space she had left inside him, and I also knew that whenever the man was finally ready to bite down into the soft skin

of the heart and move it through his mouth, I would taste on my tongue just how sweet her blood had been.

I dreamt I dreamed about hearts for years and years.

I dreamt the wolves saved all my teeth for later.

I dreamt all the geese lay dead on the highway.

I dreamt the highway was the hands of me as a man and the geese were me as a babe.

I am walking through a village. And in the village, winter light works in a factory and sleeps in a bed, like a man, and all the strawberry fruit are dead. The ancestors zip up their dark pants before touching the soup cold. The ocean makes a tundra sound. I do not know how to write. The tables are taller than I am. I do not know the grandfathers I do not know. I do not want to talk about a girl. When I walk through the day, there is a big bone covering my entire body. When I sleep, the bone sleeps too and my body can float out from under it. I follow the ants into the animal field. He is there. The man I keep dreaming of. The one with birds sleeping in his beard. The one swallowing down what he has loved. He is standing in the field I dream around him. He is acorns. Is a sapling. I see him become a mountain tree. Watch him become a lake with a hole in his middle. Become a dead fox on his own shoulders. So gradually it happens fast. And the lady from before is the skin of that dead fox. And he thinks her body is still warm around his neck. And she still thinks she is wet because her leg has gone missing. But the leg ate itself after it ate both of his. And I watch them try to dance alone. But tundra songs do not make for good music here. They are wearing each other's clothes inside out. They mourn the same body but do not know this. The body could be their son but it is older than they are. From two fields over I watch, safe. I have lemon yellow. I thank soft petals in the country. I carry an urn of blood and place it in the cemetery to evaporate. There is an ugly house with one window. The man sets the house on fire and says to the red birds, loud enough so I can hear: *This place cannot be true, it burns because it smells sweet little boy.*

And I want to go home.
But there's no sign of my horse. I do not know when he lost me.
I dreamt I was on a bird with a lantern in my mouth.
But I don't know what brought me here.

When the horse returned I was waiting.

On the horse's back was a man slumped over. I pulled the man off. There was an arrow sticking out of his mouth and I didn't know what shot him but he's saying how the mountain is up ahead and that we don't have far to go and could I sing him that song I used to sing to him long ago but I ain't that old so I don't know how long ago it could have been or really what the song could be because I only know him here but I start singing something Mom sometimes sings around the house and he says *Yes that's the one, the one that mother used to sing to us and you sung it to me one time when we were riding through the far lands on the back of that horse and it was right after I was woken in the middle of the night by those thieves.*

And I said *Thieves?* And he said *Yes, there was a white deer that had found me and she carried me on her back and we were carrying bags of seeds and leaves to carry through the far lands to the mountain and the thieves wanted our seeds and I tried to fight them but they put this arrow through my mouth and my deer looked at me and then followed the thieves into the night.*

And I asked him what the seeds were for. He said they were for cucumbers and tomatoes. He said *Was going to grow them. Out in the part of the world that is flat and filled with emptiness, where the salamanders sit upon the orange rocks and the scorpions sit beneath them.* I told him I love cucumbers but don't like tomatoes and he told me he didn't like tomatoes either but that maybe they were something he would like if he had grown them himself cuz like his mother used to say *It is hard not to love something when you have seen where it started* which sounded like something my mother might say but I didn't say anything cuz I liked hearing him talk and I asked him if he wanted me to help him pull the arrow out of his mouth and he said yes but maybe not just yet that he was afraid that if he pulled the arrow out of his mouth, much as it was hurting and much as it was filling his mouth with blood—which he needed to spit out every second sentence it seemed—if the arrow was gone he didn't know how much of the story of the thieves he would remember and if he forgot the thieves perhaps he would forget the white deer and if he forgot the deer then there'd be nothing left for him to remember about the nights when it was just the two of them under the sky, when the moon was so yellow there was no need for either of them to sing to it, when they would lay under the quiet stars until they both fell asleep, when the campfire would go out on its own, when this didn't matter because they both slept close enough to keep the other warm and if the arrow wasn't in his mouth poking out of his cheek he didn't know if he'd remember how to keep warm with something else anymore.

Maybe because of the arrow, I only understood some of what he was saying but I said *Okay* and *Well you just tell me when and I'll help you sir* and he said *Okay but don't call me sir* and I said *Okay sir ohp, sorry mister* and started whistling and he tried to join me but on account of the arrow he couldn't and I asked him if he even could and he said *Everybody knows how to whistle, Virginia taught me that.* And I asked him if Virginia was the name of the deer and he said *No, it was just a place I used to go to when I was your size* and *But she could've been named Virginia as she made it feel like I was back in that place I traveled through when I was your size.*

And then, except for me whistling, it was quiet. And then in the dream he said real soft like *I think maybe the thieves were actually following my deer. That that's who they were coming for. She was theirs. Or rather they were hers. And they just took my seeds too.*

And then it was quiet in the dream again. And I told him there was a white deer that came to me too. And I told him how she had come one night and carried me through the underworld where all the birds were and because everyone becomes animals in the next world, so I wouldn't feel out of place amongst the dead, I became a bird too. I told him that the part of the kingdom we were in was the city of birds, and the deer, she was queen of the dead. And I asked him what the thieves looked like and he got a weird look on his face and said they had beaks. So maybe they had come for her I said and that maybe she went back with the dark birds not cuz she wanted to but cuz she had to return, because it was the home she knew. And he nodded but didn't say anything. And I told him that I didn't know why she had to also take his seeds for their garden though. And he didn't say anything. And then I told him about Mom's garden and what she tells us about the worms in the dirt, and he smiled. And then we didn't say anything. Cuz like I sometimes say to Mom sometimes there's a reason to be quiet and sometimes it just feels nice.

Me and the man followed each other's hearts over the coffee colored earth. Our heart led us towards many places. We watched the fireworks open heaven above a small village. In Russia the people danced with masks of painted burlap. In the Mediterranean we ate raw and salted the rainbowed fish we caught. Into the widest of the earth's rivers we flung our boots. When we came to the devil's kingdom, barefoot as we were, we were welcomed. Left alone in a great hall we sat in the devil's chair. When he returned he chased us around his throne. I threw my bones against it to show him what real music sounded like. He chased us outside. When the green warmth of the world touched our backs we turned into geese. The feathers he snatched as we flew off, were spit in his face. We flew South. Flew far enough South that we flew North. The devil got so lonely for us he couldn't sleep and so he just sat. In the cold light, all night long in that tall dark chair, his hair falling out. The throne room collected the hours like ghosts. Everyone in the castle stayed in their rooms.

We flew East. Flew so far East we went West. Found ourselves in a countryside that had called us home. Came upon familiar castle spires. When we landed on the devil's roof he declared a holiday. Everyone took the day off. Grandfather showed up and said *Look at this!* and made small birds out of large ones. My little goose heart was clenched like a fist. I didn't even realize this until it loosened. And pennies of silver fell from its grip tumbling into the world. My skin fell from my shoulders in a cascade of tears. I stepped out of it like a bathtub—couldn't describe what I was made out of underneath. But you were made of the same stuff, the whole world as well. All of us made from the same stuff. The weathervanes and the paper cups. The anvils and the feathers. Even Grandfather and even the devil. Every ocean, every lake, every puddle. Every terrible and shadowed beast left in the woods to devour its own skin. Every soul who was raised to be a whisper and told never to grow bigger. All the same light leaking out of our holes twisting and translucent. Such soft hair every one of us grew.

*When the horse returned I was waiting.*
The man was on his back, slumped over, with an arrow in his mouth. I pulled him off. He smelled like me, both before and after a bath. I took the knife and begin cutting him open. I peeled back his skin and climbed inside, pulled his body over mine and because Mom says that if you say a something out loud it stops being a thought and starts being a truth, I said to him, to the horse, to nobody in particular, but out loud all the same, *I'll be safe here* and thought I can keep him safest from in here, all the dead shining in the sky.

It took many years to find my way back home. By the time I had I was a grown man slung across my own back and it was so many years since returning to my bedroom window that the boy I was didn't recognize me, even as he climbed on my back, even as I carried him through the dream world, carried beside the man he would become, even as he cut my belly open and climbed inside my body to protect himself, even as he climbed out to become the very same creature that carried him back home to the boy he was.

I sat in the dream like it was a dead horse and I needed to get out the cold. I stayed in its belly all winter long. When spring came, I crawled out. A young boy thought I was a newborn foal. He watched as I began chewing on the field's young flowers. Slowly he walked closer and like the low hanging sunlight of the afternoon, ran his orange and gold fingers through the short hairs running across my shoulders and started to pet my neck. I felt his bravery beginning in the tips of his fingers and spreading to the small sweet fig of his heart. My new body purple and forming pushed color to its still soft kneecaps and began standing on all four of its new legs.

# ACKNOWLEDGEMENTS

Some of the work in this book first appeared in some form or another
in *Paper Darts* and *Nailed Magazine,* and there are some places that are echoes
from out of Anis' book *The Feather Room.*

Thank you:
to Dalton Day, Wess Mongo Jolley, & Hanif Willis-Abdurraqib for the wonderful notes.
To the Vermont Studio Center, for the time & space that allowed me to find my way back into a
place for myself. To Sara Boettiger, for opening your Berkeley home to me, where,
finally, I was able to make this book—it would not be what it is without your extremely kind gesture.

To Derrick, for the patience, support, & years of inspiration. & for the use of your garage.
To Trudy, for allowing yourself to be loved, & forcing me to do such, when I really needed to love
something. To Chris: you know why. To Cristin: you also know why. But as you like me voicing
your accolades publicly: for helping me have a place to live & more so, a life to keep living inside of.

To Shoke, Naysan, & Pop, for housing my love, for the quiet placing of your hands on my life
& for never taking them off.
& to Mom, for bringing my heart to this place, for showing it how to lead itself through
darkness, & for keeping it here when it forgot how.

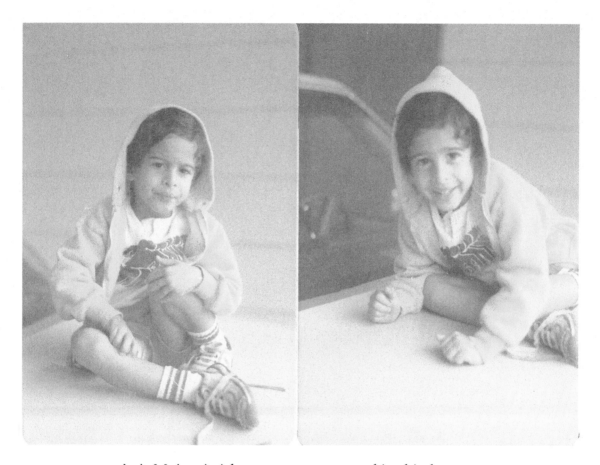

Anis Mojgani picks up pretty stones and is a kind man.
He is not perfect and he doesn't try to be. But he does try to be better.
Some days he wants to leave this place. Every day he fights not to.
Besides *The Pocketknife Bible*, he has three books out on Write Bloody.
From Louisiana, he currently lives in Oregon.

# IF YOU LIKE ANIS MOJGANI,
## ANIS LIKES...

*Slow Dance with Sasquatch*
Jeremy Radin

*Redhead and The Slaughter King*
Megan Falley

*The Year of No Mistakes*
Cristin O'Keefe Aptowicz

*This Way to the Sugar*
Hieu Nguyen

Write Bloody Publishing distributes and promotes great books of fiction, poetry and art every year. We are an independent press dedicated to quality literature and book design, with an office in Austin, TX.

Our employees are authors and artists so we call ourselves a family. Our design team comes from all over America: modern painters, photographers and rock album designers create book covers we're proud to be judged by.

We publish and promote 8-12 tour-savvy authors per year. We are grass-roots, D.I.Y., bootstrap believers. Pull up a good book and join the family. Support independent authors, artists and presses.

**Want to know more about Write Bloody books, authors, and events?
Join our mailing list at**

## www.writebloody.com

# WRITE BLOODY BOOKS

*After the Witch Hunt* — Megan Falley

*Aim for the Head: An Anthology of Zombie Poetry* — Rob Sturma, Editor

*Amulet* — Jason Bayani

*Any Psalm You Want* — Khary Jackson

*Birthday Girl with Possum* — Brendan Constantine

*The Bones Below* — Sierra DeMulder

*Born in the Year of the Butterfly Knife* — Derrick C. Brown

*Bouquet of Red Flags* — Taylor Mali

*Bring Down the Chandeliers* — Tara Hardy

*Ceremony for the Choking Ghost* — Karen Finneyfrock

*Courage: Daring Poems for Gutsy Girls* — Karen Finneyfrock, Mindy Nettifee &
Rachel McKibbens, Editors

*Dear Future Boyfriend* — Cristin O'Keefe Aptowicz

*Dive: The Life and Fight of Reba Tutt* — Hannah Safren

*Drunks and Other Poems of Recovery* — Jack McCarthy

*The Elephant Engine High Dive Revival* anthology

*Everyone I Love Is a Stranger to Someone* — Annelyse Gelman

*Everything Is Everything* — Cristin O'Keefe Aptowicz

*The Feather Room* — Anis Mojgani

*Gentleman Practice* — Buddy Wakefield

*Glitter in the Blood: A Guide to Braver Writing* — Mindy Nettifee

*Good Grief* — Stevie Edwards

*The Good Things About America* — Derrick Brown & Kevin Staniec, Editors

*The Heart of a Comet* — Pages D. Matam

*Hot Teen Slut* — Cristin O'Keefe Aptowicz

*I Love Science!* — Shanny Jean Maney

*I Love You Is Back* — Derrick C. Brown

*The Importance of Being Ernest* — Ernest Cline

*In Search of Midnight* — Mike McGee

113

CPSIA information can be obtained
at www.ICGtesting.com
Printed in the USA
LVOW05*2326030216

473551LV00018B/163/P